Light in Pastel

PAUL HARDY

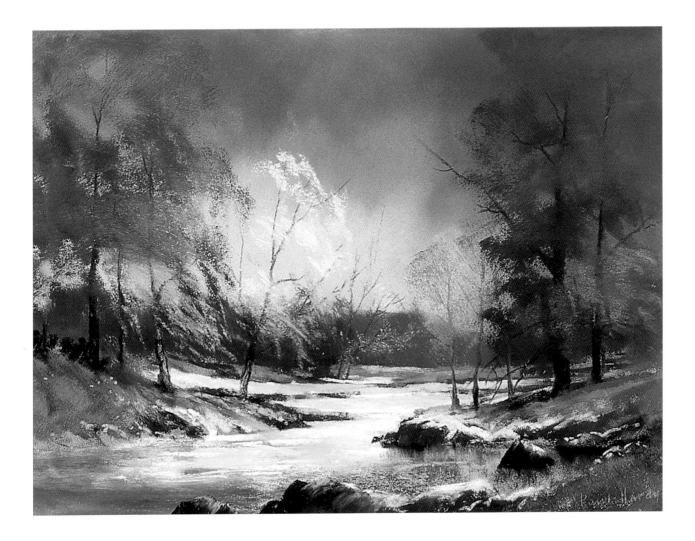

SEARCH PRESS

First published in Great Britain 2004

Search Press Limited
Wellwood, North Farm Road,
Tunbridge Wells, Kent TN2 3DR

Reprinted 2006

ISBN 10: 1 903975 60 3
ISBN 13: 978 1903975 60 2

The Publishers and author can accept no responsibility for any consequences arising from the information, advice or instructions given in this publication.

The Publishers would like to thank Winsor & Newton for supplying some of the materials used in this book.

Suppliers
If you have difficulty in obtaining any of the materials or equipment mentioned in this book, then please visit the Search Press website for details of suppliers: www.searchpress.com

Alternatively, you can write to the Publishers at the address above, for a current list of stockists, including firms who operate a mail-order service, or you can write to Winsor & Newton requesting a list of distributors.

Winsor & Newton, UK Marketing
Whitefriars Avenue, Harrow,
Middlesex, HA3 5RH

Publishers' note
All the step-by-step photographs in this book feature the author, Paul hardy, demonstrating his pastel painting techniques. No models have been used.

Printed in Spain by A. G. Elkar S. Coop. 48180 Loiu (Bizkaia)

I would like to thank Roz Dace and John Dalton for their ongoing support and guidance.

Page 1
Morning has Broken
Size: 410 x 290mm (16¼ x 11½in)
The early morning sun shines through a break in the clouds and highlights the buildings and the land close by. The concentration of light picks up the colours which are further emphasised by being set against the dark clouds.

Page 3
Afternoon Light
Size: 305 x 230mm (12 x 9in)
The reflected light in the water brings this scene to life. The tonal value is balanced and holds the composition together.

Page 5
Autumnal Evening
Size: 290 x 215mm (11½ x 8½in)
Here I used the available light to create a strong focal point. The light was quite strong, producing bright colours which are intensified by the dark foreground.

Light in Pastel

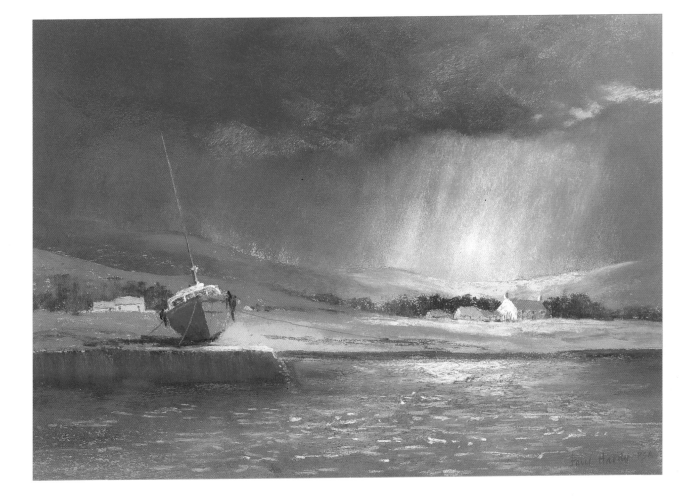

Contents

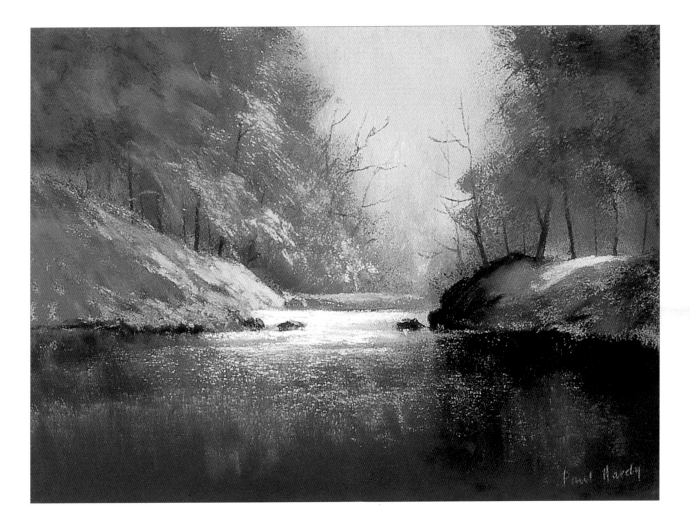

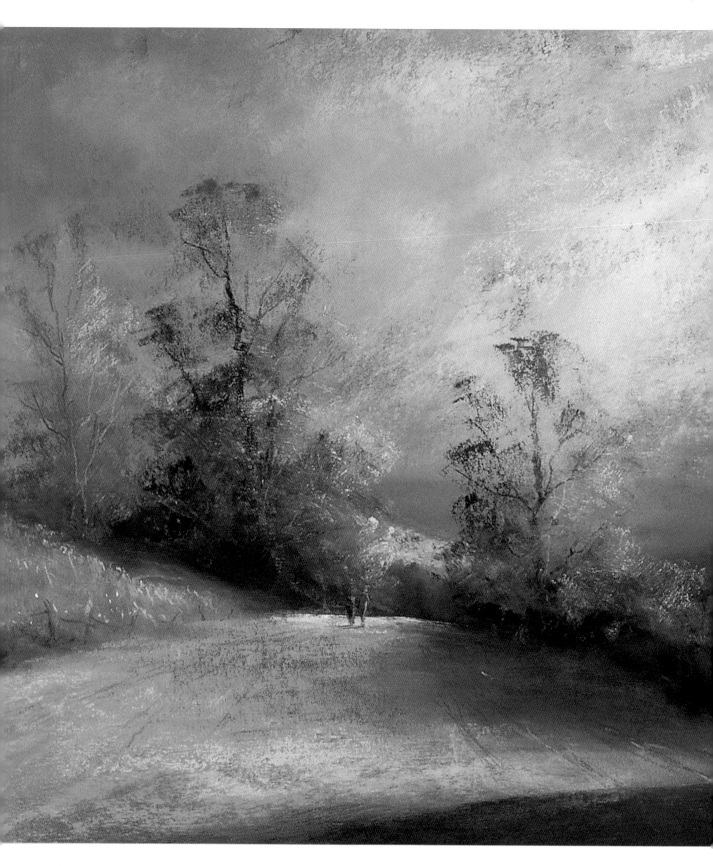

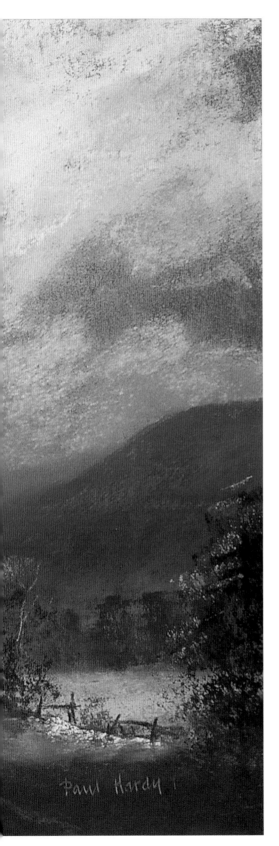

Introduction

One of the most important aspects of painting in any medium is an understanding of light. Light enables us to see a subject, and the way the light strikes the subject helps us see it in three dimensions. If there is no light, there is no shape and form.

Light is an intangible quality. It is constantly changing; one minute a scene can appear flat and uninspiring, then, suddenly, the light changes and the same scene becomes very dramatic. Bright sunlight is often thought of as good light, but it is not always the best light for artists. Subdued or dappled light can often add drama to a painting. This is especially true if you use the available light to focus on a particular part of a composition and create a bright focal point in an otherwise bland scene.

Understanding the effects of light requires careful observation. You have to look at a subject and 'see' the relationship between lights, darks and mid-tones, and the strength of colours.

Compare highlights and shadows – in strong light, these are bright and dark respectively, but the contrast between them becomes less in diffused light. Look at reflected light and see the effect this has on shadow tones. Shadowed areas are as essential as bright highlights in any composition; both are part of the whole picture, and we cannot think of one without the other. Notice the effect of atmospheric perspective; colours lose their strength and become cooler as they recede into the distance. Observe how the patterns created by light vary with the time of day and the prevailing weather conditions.

Pastel is a wonderful medium with which to explore all the exciting possibilities of light. Capturing light in pastels is an adventure that involves risks, but these have to be taken if we are going to realise the potential within us. In this book, I show you how I go about recreating the effect of light in all its glory. I hope the step-by-step projects and the gallery of finished paintings will inspire you to greater things.

Towards the Moor
Size: 440 x 335mm (17¼ x 13¼in)

I painted this scene on a warm summer evening. It was rather cloudy, but there was a top light that created soft shadows and muted colours. The two figures were added to bring the scene to life and add a sense of scale to the composition.

Materials

The two essential materials are the pastels and the painting surface. Both are important and, as there is a wide range of each available, it is wise to experiment with different types of pastels on a variety of surfaces and discover which serves you best. You will find there is a certain 'feel' about painting with pastels which becomes very personal and plays an important part in your artwork.

Pastels

There are three basic types of pastel: soft pastels, hard pastels and pastel pencils. They can be used separately, but combining the different types of pastel is part of the pleasure of using them.

For me, soft pastels are the most versatile and flexible of the three types, and I use them for most of my paintings. They release the pigment freely, so a light touch is necessary, especially when mixing lots of colours together. Too much pressure will clog the surface and deaden the colour and texture in the finished painting. Use the tip of the stick to make small marks and the side of it for larger areas.

Manufacturers identify their colours in different ways. Winsor and Newton, for example, produce five tints (from very pale to very dark) of named colours, while other brands use a numerical identification (green 1, green 2, etc.). In this book I use my own terminology because, when the wrappers have been removed, the sticks lose their colour identification.

Hard pastels are firmer and less likely to break, but they do tend to flatten and compact the painting surface, making the stick skate across the surface if it is overworked. They are, however, very good for adding final details to a soft pastel painting and are particularly useful as a drawing material.

I tend to restrict the use of pastel pencils to drawing the basic outlines of a composition. I have found that it can be difficult to maintain a good line on the smoother papers. Conversely, on a very rough surface, marks made with pastel pencil can be broken and lack definition.

Painting surfaces

The painting surface (or support) has a vital part to play in the finished painting. There is a huge range of papers to choose from and selection of the right surface is as important as the pastels used. It is difficult to be dogmatic about this as it is a very personal choice. The most important point about the painting surface is that it must have a degree of roughness (or tooth) to hold the pigment released by the pastel stick. There are lots of different brands of pastel paper (smooth on one side and textured on the other), but, more often than not, I paint on a fine-grade abrasive sandpaper. These abrasive papers have a pronounced tooth that is able to take up a lot of pigment without clogging.

Pastels are more effective on good papers, but not to the exclusion of other surfaces, and you do not need expensive papers to practise on. Visit your local art shop or contact some of the mail-order firms who will be only too willing to send you samples of what they have available.

A certain freedom is required to experiment and to take chances – you must do if you are going to progress. We all make mistakes, but pastel is a forgiving medium and can be worked over!

Easels

The painting surface should be as near vertical as possible to allow excess pigment to fall away from the surface, so an easel is a must. If you work on a flat surface, the excess dust could make the painting process difficult and you could lose the sparkle and immediacy that is exclusive to pastel painting. I like to stand when painting, but there are some excellent table-top easels for those who prefer to sit.

Other equipment

I use simple sheets of plywood to support the paper and drawing pins to attach the paper to the board.

I usually blend colours on the paper with my hand but, occasionally, I use a paper stump to blend tiny areas of colour in a confined area.

A spray fixative can be useful to firm up the first layers of pastels, prior to overlaying others.

Mixing colours

Unlike most other mediums, pastel colours are mixed directly on the paper by adjusting colours as you work. There are three basic methods – blending, scumbling and hatching.

Blending

This is the most common colour mixing technique, and I use it on most of my paintings. Broad strokes (made with light touches of the side of a pastel stick) are used to lay on one colour. A second colour is applied on top, then the colours are blended together by rubbing with the side of your hand or a finger.

Scumbling

Here, different colours are applied with loose scribble motions, one on top of another. This free application creates a rich medley of colour without specific definition – the only blending that occurs is due to the pressure applied.

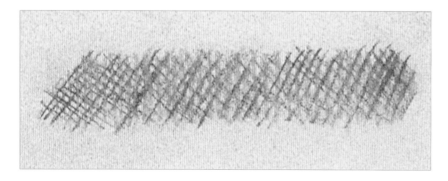

Hatching

This is a distinctive method of mixing colours. A series of parallel lines is drawn with one colour, then another series is drawn on top with a second colour at a different angle. This technique can be worked up with several colours, all at different angles, to produce strong tones. This method can be used to good effect in shadow areas.

Capturing light

Our natural source of light is the sun which, when high in the sky on a cloudless day, creates a wide tonal contrast – very bright highlights and very dark shadows – and warm colours. But, even on a bright day, distance (or atmospheric perspective) affects the tonal value and colour of objects that are further away than those in the foreground.

More often than not, however, other atmospheric conditions apply, and these can have a considerable effect on the amount and type of available light. On a very overcast day, for example, the tonal contrast is considerably reduced – dark tones become lighter and pale tones darker – but dramatic paintings can still be created.

So, capturing the drama of light is all about the relative lightness or darkness of the tones in a particular scene. Light gives life and vitality to a painting, and below and on the following pages are a few examples of different lighting conditions.

When you look at a subject through half-closed eyes, colour and detail are virtually eliminated and you see just the basic shapes and their tonal values.

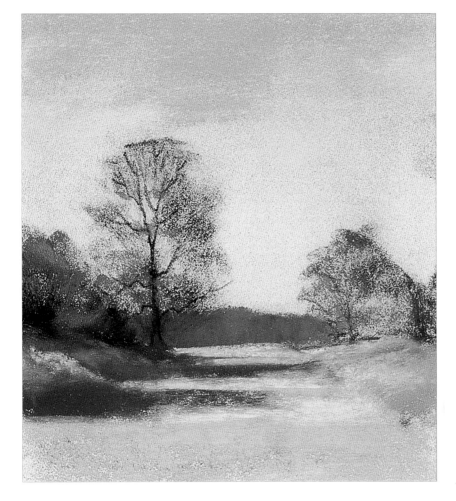

This scene was painted early on a fine autumnal morning.

The low sun limits the contrast between the light and dark tones, but it is just high enough to create patches of bright colour on the foliage and to cast long shadows across the landscape.

The warmth of the foliage is balanced by the coolness of the other parts of the composition. The sense of stillness and peace is accentuated by the simple sky and the horizontal shapes of the foreground shadows.

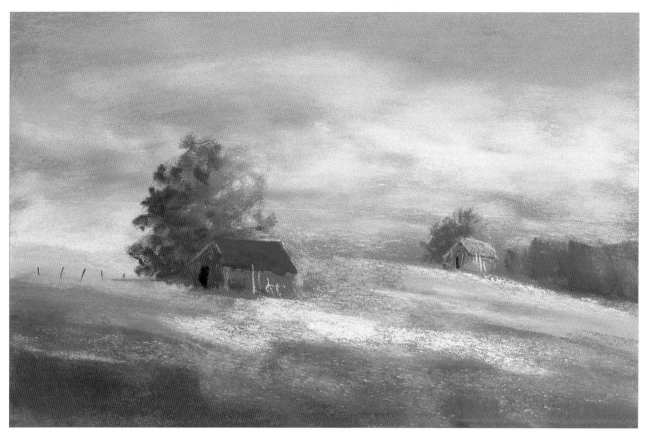

The two buildings in this sketch are actually the same size, but perspective has the effect of making the distant one smaller. The colour of their roof tiles is identical, but atmospheric perspective makes the more distant roof paler and cooler than the other.

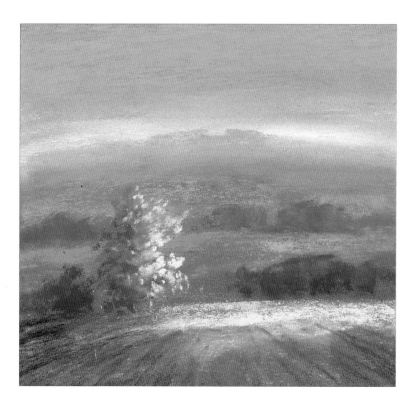

In this simple composition the distant horizon is a long way away. There are several 'layers' in the landscape, and each becomes paler and cooler the further away they are. Note also how the marks used for objects in the foreground are more pronounced than those further back.

Here we have a snow-covered mountain sat against a wintry sky. You can clearly see the wide tonal contrast between the bright sunlit snow and the deep shadows in the foreground. We all know that snow is white, but note how, on the shadowed side of the mountain, it takes on a blue-grey cast (a reflection of the colour of the dark sky above).

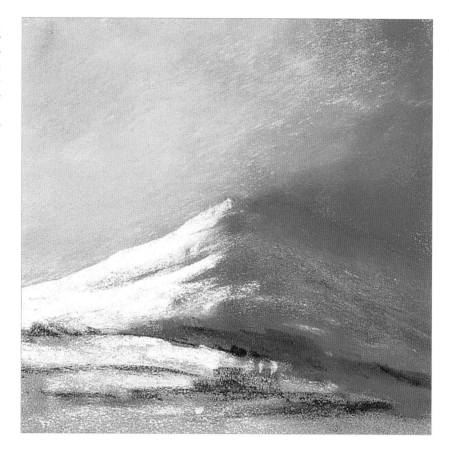

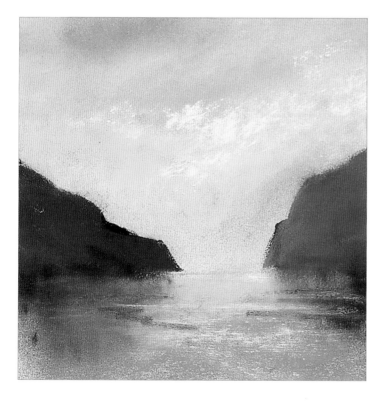

For me, the few minutes before and after sunrise is a beautiful time of the day. You never really know what to expect, and I find it exciting to stand in darkness and watch the colours of the day gradually reveal themselves. The colours and tonal patterns change every second, so you have to be quick to capture particular moments. Not every sunrise is spectacular, but each is unique. On this day, an early morning mist diffused the light, making the cliffs appear rather intense against a cool yellow sky. The wet beach in the foreground, illuminated by reflected light from the clouds overhead, holds the whole scene together.

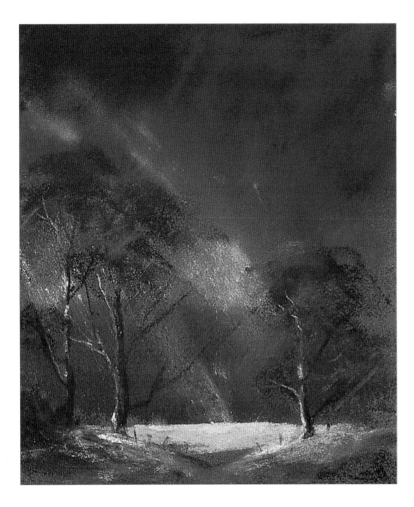

Here, sunlight filters through a break in dark storm clouds to illuminate a quiet woodland glade with a burst of bright light. The shafts of sunlight, visible against the dramatic dark sky, also highlight the left-hand edges of the large foreground trees.

The warm colours in the glade contrast well with the surrounding dark tones.

The atmosphere in this autumnal scene is enhanced by gentle sunlight from the left-hand side. The soft shadows, created by the light being filtered through the foliage, were just intense enough to complement the seasonal colours.

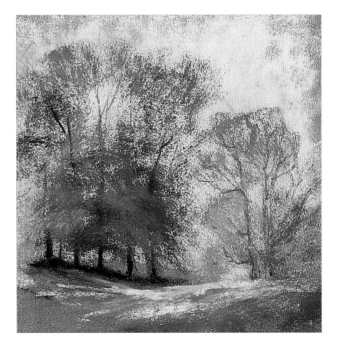

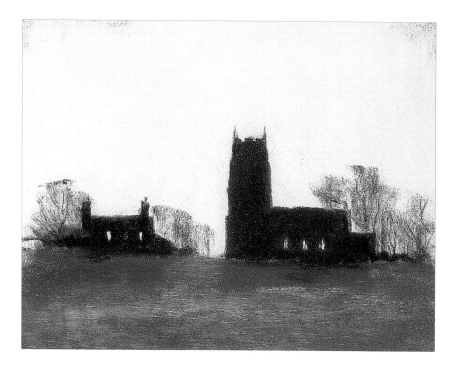

This is obviously a late evening scene; the sun has set but the sky is still quite light. The vertical walls of the church and cottage are dark silhouettes set against the light sky, but they still retain their shape and form, and some evidence of colour.

The relatively flat foreground has more colour because it is still lit by reflected light from the sky above.

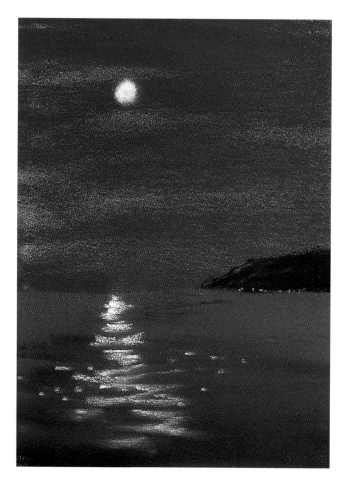

Moonlight (reflected light from the sun below the horizon) falls on a scene totally in shadow. This cool reflected light, of course, is not as strong as direct sunlight, but it is often strong enough to illuminate the landscape.

In this simple seascape, the bright reflection of the moonlight on the surface of the sea tapers back to the horizon line. The distant headland is very dark against the moonlit sky and sea, but it still has shape and form. The scene is brought to life by tiny bright marks that indicate a seaside town.

Overleaf

It always amazes me how the same scene can change so much throughout the year. The four sketches overleaf were painted in different seasons.

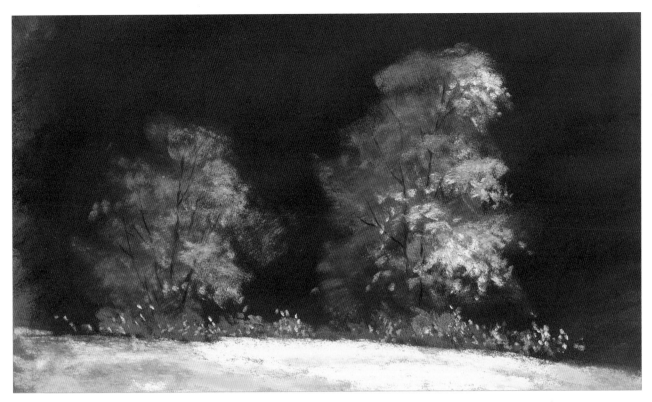

Strong and dramatic

Gentle and relaxing

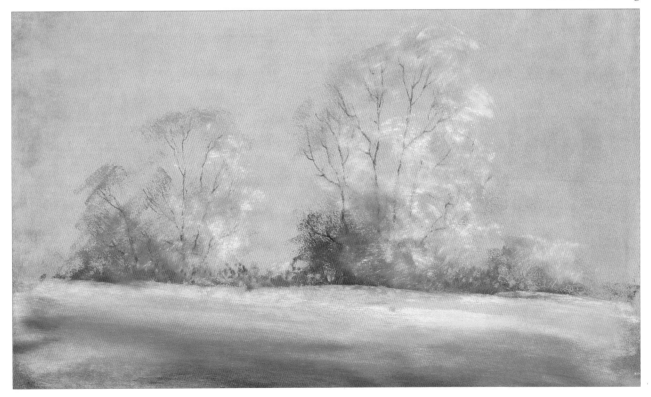

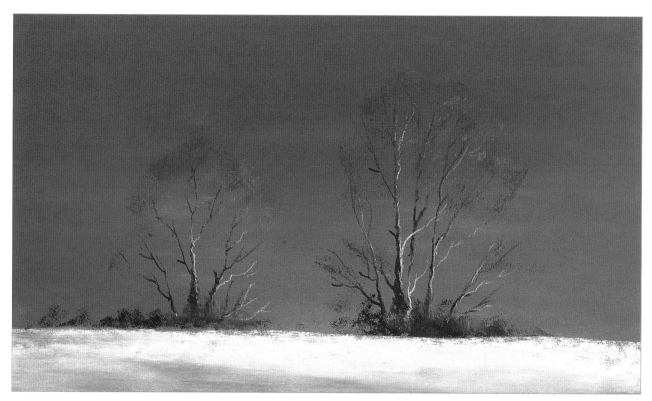

Cold and threatening

Warm and inviting

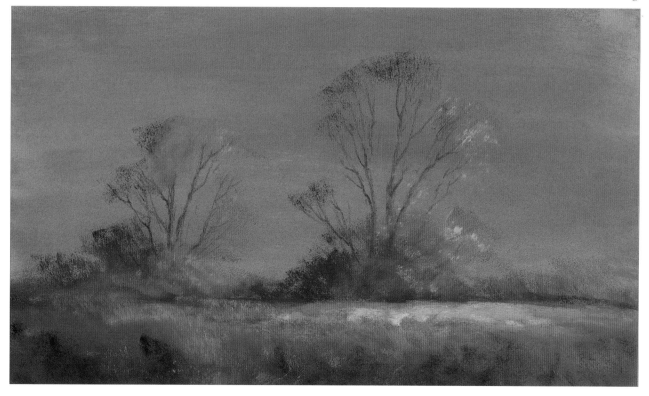

Landscape

The landscape has so much to offer the artist, that I had to make a landscape my first demonstration. I have chosen a simple panoramic composition with a good interplay of light and shade, and distinct foreground, background and sky areas.

It is an autumn scene, with lots of warm colours in the foreground and middle distance that provide a balance to the cooler greys and blues in the sky.

You will need

Soft pastels:
 white
 cool-grey (dark)
 warm-grey (medium, dark and very dark)
 cool-blue (pale)
 warm-blue (pale and dark)
 purple (dark and very dark)
 cool-yellow (pale and medium)
 warm-yellow (medium)
 orange (pale, medium)
 cool-red (very pale)
 raw sienna (pale and dark)
 burnt sienna (medium and dark)
 warm-green (pale)
 charcoal pencil
Hard pastel: white
Pastel pencil: white
Charcoal pencil

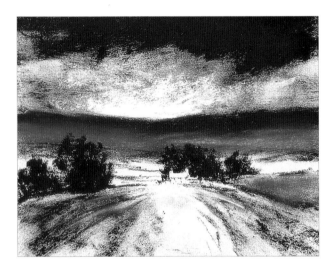

This tonal sketch, worked up in situ with charcoal and white pastel, was used in conjunction with my colour notes as the reference material for this demonstration.

1. Use the charcoal pencil to draw in the horizon line and the basic outlines of the landscape on to the paper.

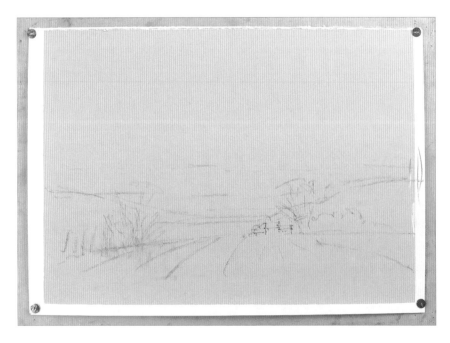

2. Use the side of a medium warm-grey pastel to block in the far distant hills on the horizon and define the bottom edge of the sky.

3. Use the side of the same grey pastel to block in the top part of the sky.

4. Use the side of a pale warm-blue pastel to block in the middle area of the sky.

5. Build up the colour with a dark warm-blue.

6. Add a very pale cool-red to left-hand side of sky.

7. Accentuate the top right-hand corner of the sky with a very dark warm-grey . . .

8. . . . tone it down with the medium warm-grey, then finger blend the colours together.

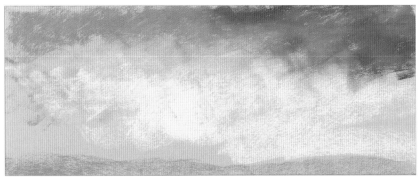

9. Now block in the basic cloud formation with a white pastel, taking this colour up into the greys and blues at the top of the sky.

10. Use side of your hand to blend all the sky colour together.

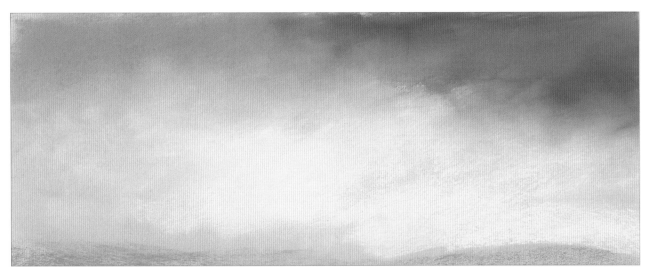

The blended sky colours after step 10

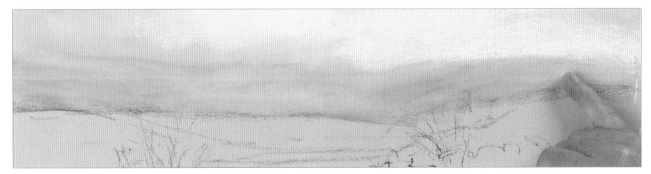

11. Overlay a pale cool-blue on the grey of the far distant hills, then, using a finger, blend the blue into the grey to create shape and form.

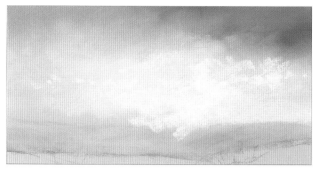

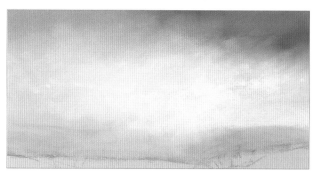

12. Add more white to emphasise the clouds, and bring some clouds down across the horizon.

13. Soften these new clouds slightly, and blend them into the horizon.

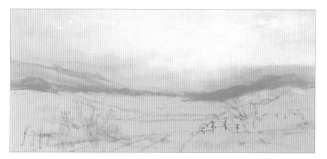

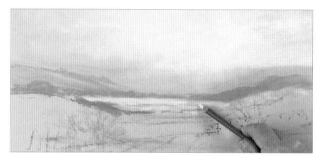

14. Use a medium warm-grey to indicate the shape of the middle distant hills. Use a dark warm-grey to block in the hedges and trees. Add touches of pale cool-yellow as reflected light on middle distance hills at left- and right-hand sides.

15. Use a medium warm-yellow to block in the meadow, then finger blend this on to the paper. Use the medium and dark warm-greys to define some hedges in the meadow, then use a white pastel pencil to soften their edges into the yellow.

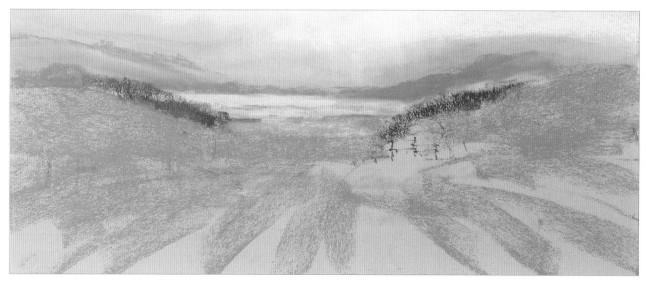

16. Use a dark cool-grey to block in trees on either side of the meadow. Use dark raw sienna to warm up the nearest part of meadow. Extend this colour up across the hills on either side, then, using broad angled strokes, block in the foreground.

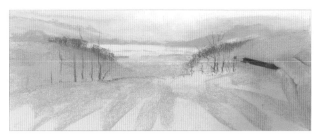

17. Blend the top of the hill into the trees, then add a few dark purple marks to the trees. Brighten the top of the left-hand hill with touches of pale orange, then use a charcoal pencil to draw in skeletons of trees at the bottom of the hills.

18. Use the side of a very dark purple pastel to block in foliage over the trees.

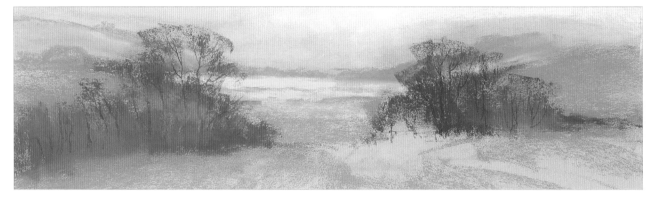

19. Working from the bottom upwards, use a finger to soften the marks, then use the charcoal pencil to re-establish the tree trunks and branches.

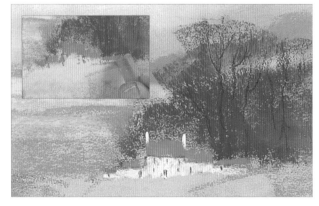 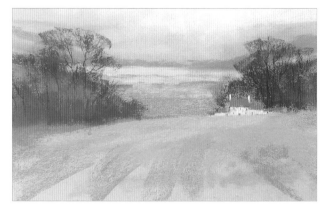

20. Use single strokes of a medium orange to block in the roofs of the building. Use the tip of a hard white pastel to block in the walls and chimneys. Use a charcoal pencil to define the edges of roofs and the doors and windows.

21. Warm up the foreground with strokes of pale raw sienna, then overlay this with touches of a medium warm-yellow. Add touches of a medium cool-yellow in the distance.

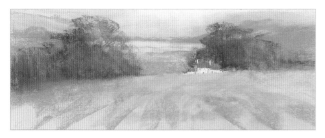

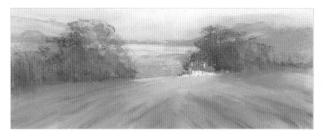

22. Work dark and medium burnt sienna pastels into the middle distant trees to suggest autumn foliage – skating over the surface to leave fine marks on top of the darker tones. Add touches of medium orange here and there to add light to the right-hand side. Overlay light touches of a pale warm-green into the top of the trees and across the foreground. Add a few highlights of a medium cool-yellow to the right-hand stand of trees.

23. Overlay the foreground area with a medium warm-grey, then use the edge of the pastel to denote furrows in ploughed field to lead the eye into the painting. Finger blend these marks to soften them, accentuate the furrows with a medium burnt sienna, then blend the more distant parts of these marks.

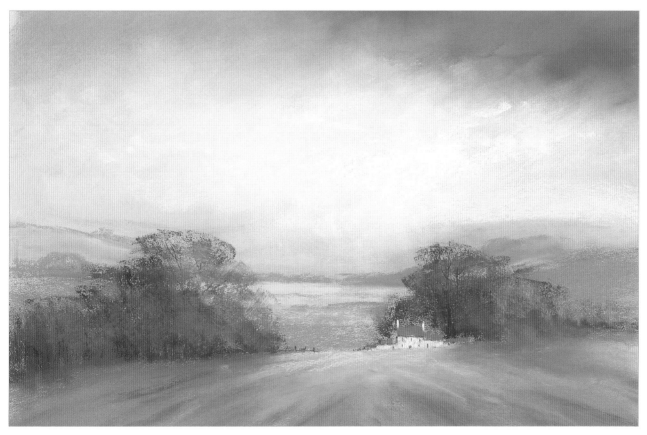

The finished painting
Size: 455 x 305mm (18 x 12in)

Having stood back to view the painting, I decided to add a few small clouds, a fence in the middle distance, and some angled strokes of pale cool yellow to brighten the far end of the ploughed field. I also decided to reduce the foreground to create a wide vista.

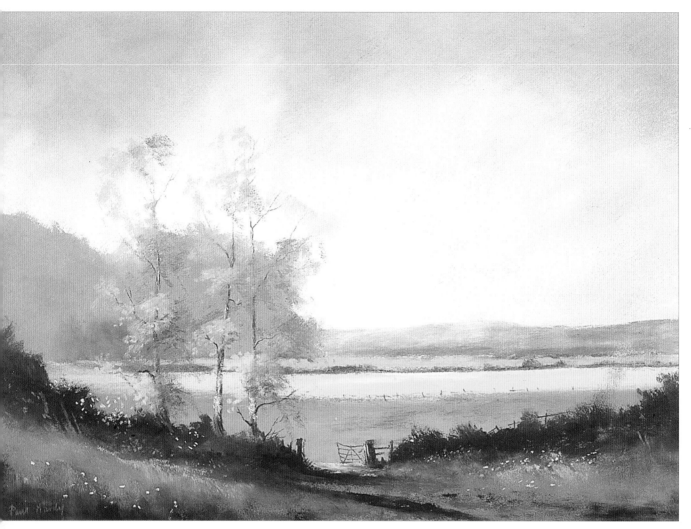

Meadowlands

Size: 365 x 260mm (14½ x 10¼in)

This simple landscape was painted on a clear evening in late spring. The horizontal structure of the middle distance suggests a sense of calm, but this is balanced by the drama of the diagonal lines of the hedges and long shadows in the foreground. The group of trees link the foreground to the sky and hold the composition together. Notice how the perspective is enhanced by placing the fine detail of the foliage and tree trunks against a less fussy background.

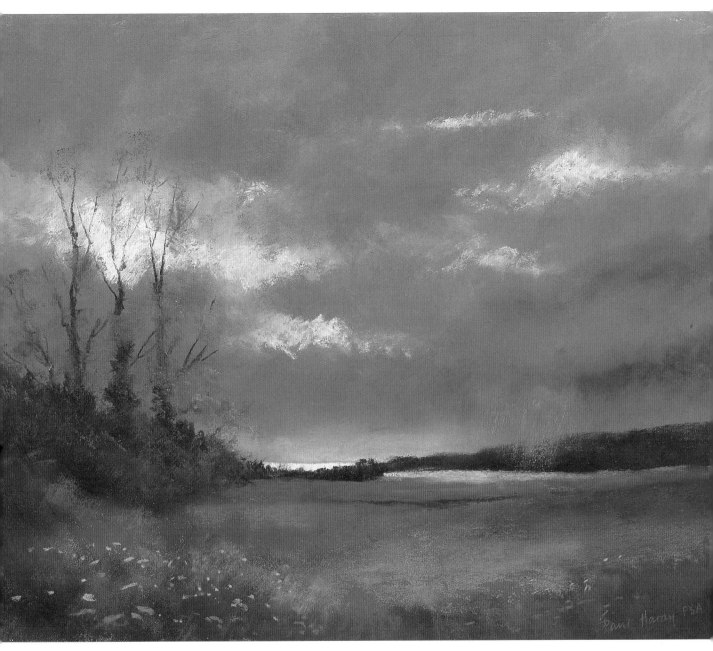

Bright Interval

Size: 410 x 335mm (16¼ x 13¼in)

Another landscape on another day – completely different in all respects to the one opposite – but still worth painting. The subdued light from the overcast sky muted all the colours and softened the shapes of the foreground objects. Tonally, there was hardly any difference between the foreground and the sky areas, but the really dark tones along the horizon, the bright patches of sunlight on the distant fields and the breaks in the clouds combined to make a dramatic composition.

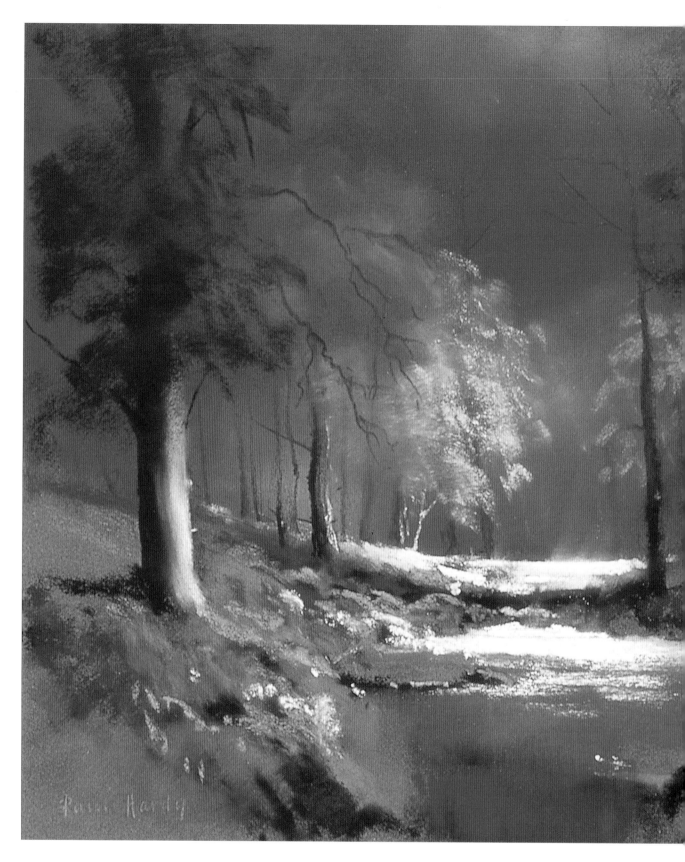

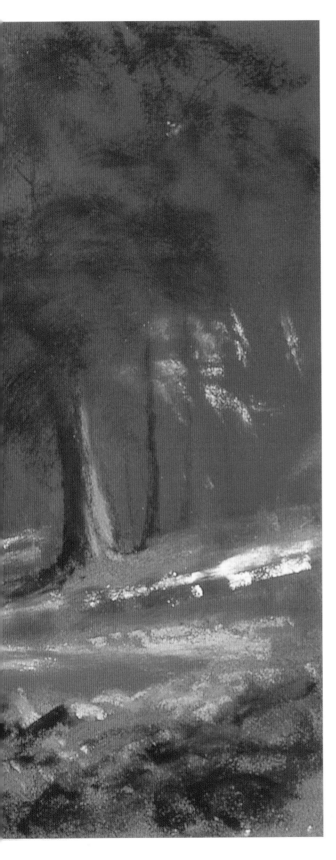

Highlights

Size: 315 x 230mm (12½ x 9in)

Shafts of sunlight, penetrating the canopy of tall trees, brought this tranquil scene to life by creating colourful highlights on the foliage and bright reflections on the surface of the water. Soft blended patches of foliage in the shady areas contrast with the patchwork of bright, more-defined shapes in the foreground.

Seascape

The subject of this step-by-step demonstration is a place I visit at least once a year, and each time it presents a different challenge. It is an estuary, where the depth of water in the river changes with the tide. On this particular visit, the tide was low, exposing the gravel surface of the river bed.

The light source, which was behind me, created the bright colours on the sandy beaches and highlighted the distant sea. I introduced drama by setting these against a dark sky.

You will need

Soft pastels:
 white
 cool-grey (very pale, pale, medium and very dark)
 warm-grey (pale, medium, dark and very dark)
 violet (pale)
 cool-blue (pale)
 warm-blue (medium and dark)
 black-green (dark)
 cool-yellow (pale)
 raw sienna (medium and dark)
 burnt sienna (very dark)
Pastel pencil: white
Charcoal pencil

I used this tonal pencil sketch as the reference for this demonstration.

1. Referring to the tonal sketch, use a charcoal pencil to draw the basic outlines of the composition.

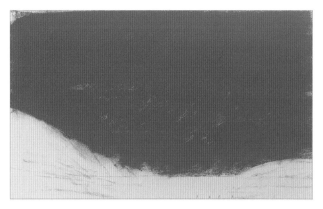

2. Use a dark warm-blue to block in the whole of the sky.

3. Use the side of your hand to rub in the colour leaving a few patches of the paper showing through.

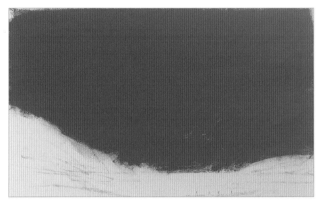

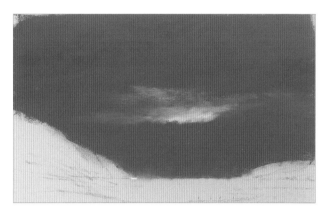

4. Overlay all the sky with a dark violet, then rub this into the undercolour.

5. Use a very pale cool-grey to lay in clouds in the centre of the sky, and a very dark cool-grey for some darker clouds at the top and right-hand side.

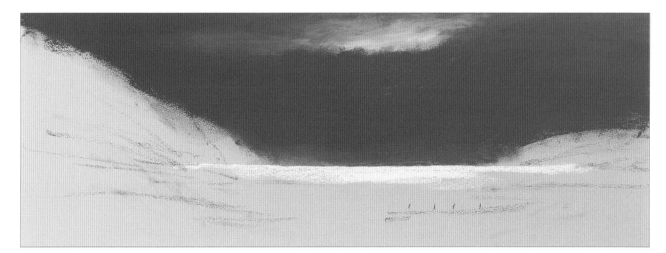

6. Use a white pastel to define the horizon line, then add a few more strokes to denote the distant part of the sea.

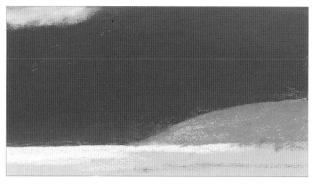

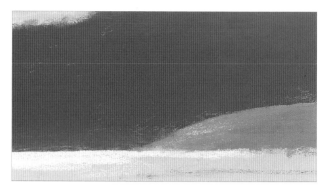

7. Use a medium warm-grey to block in the distant right-hand headland. Leave some of the paper showing through as highlights.

8. Overlay the lower part of the cliff with pale violet, then blend the colours together. Again, leave some of the paper showing through.

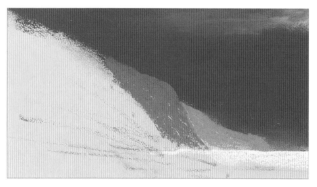

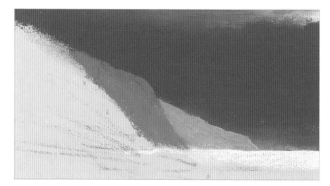

9. Work up the middle section of the left-hand cliffs with the pale violet, then lay in the furthest cliffs with the medium warm-grey.

10. Blend the pastel on the middle cliff, then overlay the distant grey cliff with scribbles of a medium warm-blue.

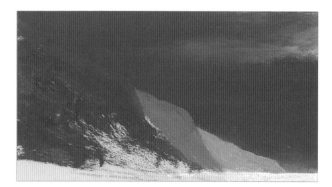

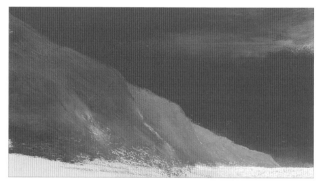

11. Use a dark black-green to block in the nearest cliff, leaving some of the paper showing through at the bottom as a highlight picking up light from sky.

12. Overlay the cliff with a medium cool-grey, accentuate the cliff edge with a pale cool-yellow, add touches of the same colour to its lower parts, then blend the colours together. Having stood back to look at the painting, I decided to dull down the · middle cliff with touches of pale warm-grey.

 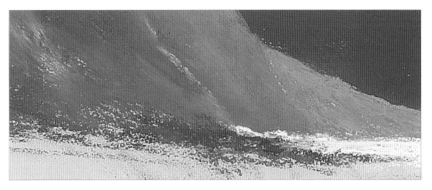

13. Use a white soft pastel to indicate spray from the waves crashing against the cliffs.

14. Use a dark violet to define an area of rocks in front of the cliffs and to accentuate the breaking waves behind them.

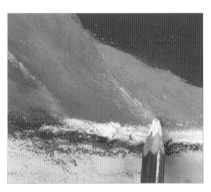 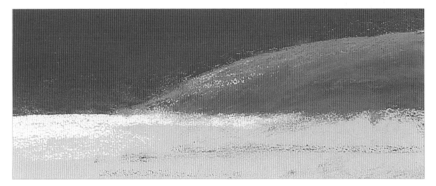

15. Use a white pastel pencil to accentuate and highlight the edge of the middle cliff.

16. Darken the bottom of the right-hand cliff with a dark warm-grey, then blend this into the undercolours to create shape and form. Use a medium raw sienna to suggest a grassy bank on the top of the cliff.

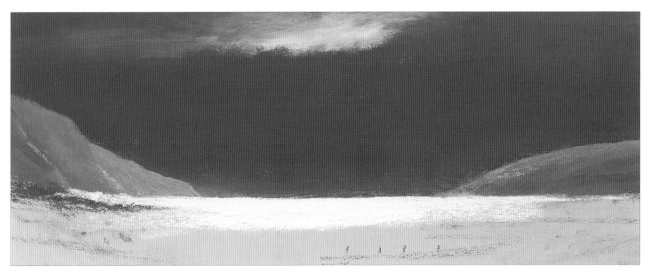

17. Enhance the distant sea with more white, extending the water across below the right-hand cliff and in front of the left-hand rocks.

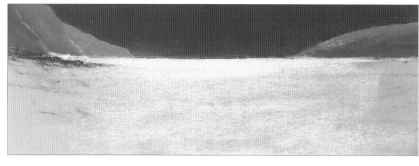

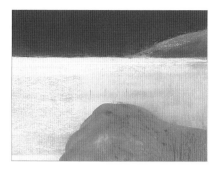

18. Working from the bottom upwards, use a pale cool-blue to block in the foreground sea, taking it just up into the distant white area. Using a pale cool-yellow, lightly skate over the blue to leave just the merest indication of light.

19. Now, using downward movements of the side of your hand, rub the colours together.

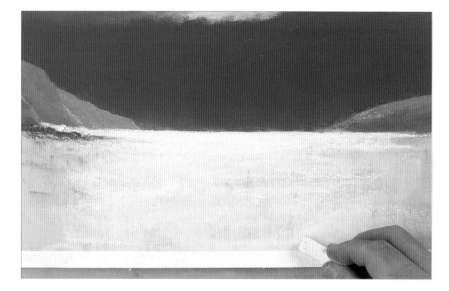

20. Use the edge of a white pastel to create a series of horizontal ripples that just break the surface of the water.

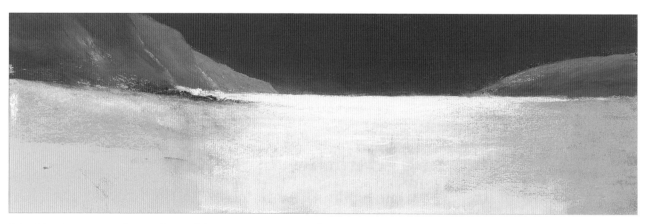

21. Skating across the surface of the paper, use a medium raw sienna to suggest the sandy beach. Overlay touches of the pale cool-yellow on the left-hand beach.

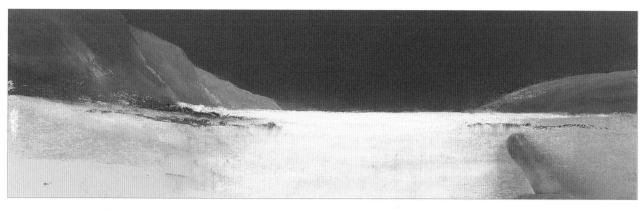

22. Use a very dark warm-grey to lay in more rocks on the left-hand beach and the merest suggestion of some more on the right. Use the tip of your finger to pull down reflections into the water.

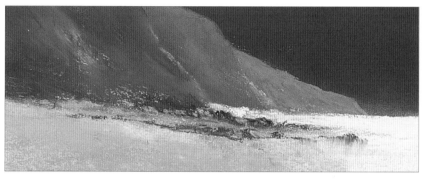

23. Use the medium cool-grey to add highlights among the rocks under the left-hand cliffs.

24. Use the charcoal pencil to reinstate the old breakwater posts and their reflections.

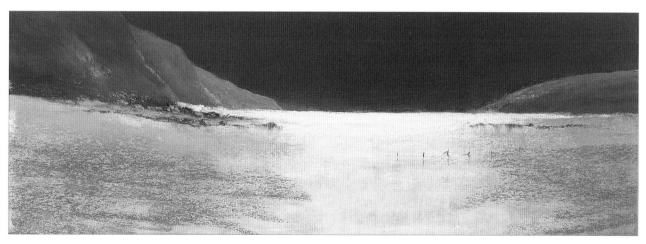

25. Use a pale cool-grey to tone down the sand banks at either side, and to block in the rest of the beach at the left. Overlay the foreground area at each side with a dark raw sienna.

 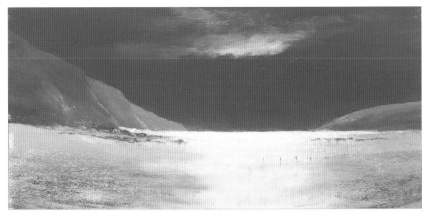

26. Finger blend the edges of the sandy beaches into the water.

27. Drag the side of a very dark burnt sienna pastel across the surface to denote shingle in the foreground.

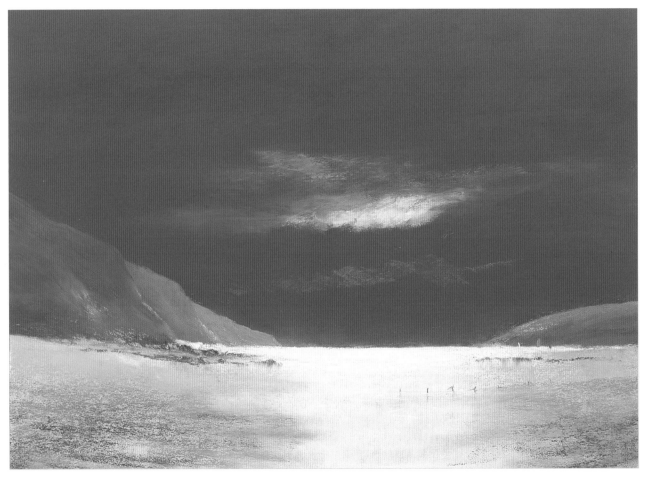

The finished painting

Size: 455 x 325mm (18 x 12¾in)

Having looked at the painting at the end of step 27, I decided to intensify the whites in the cloud formation. I also decided to add a few tiny bright spots of colour in the form of sailing boats set against the right-hand cliff.

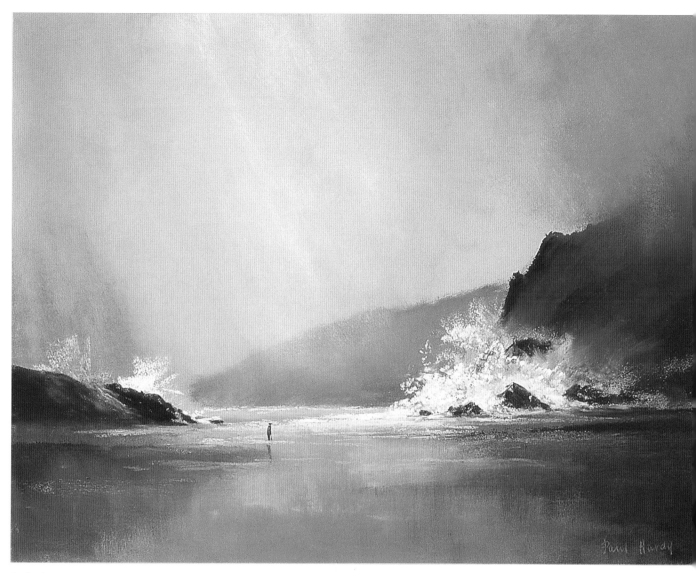

Isolation

Size: 305 x 215mm (12 x 8½in)

Waves crashing on a rocky coastline are always dramatic, but, in this very remote location, I also wanted to convey the sense of isolation. The combination of the sombre sky, with its suggestion of rain, and the muted colours of the cliffs and beach contrast well with the bright spray. The small figure provides depth and scale to the scene, and emphasises the loneliness of the beach.

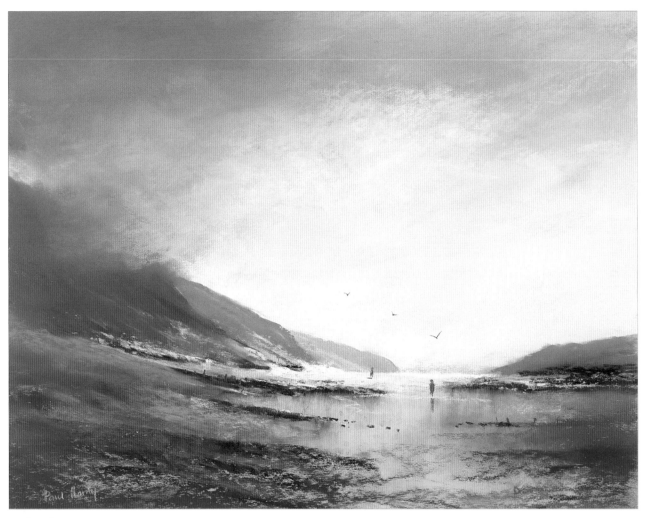

Red Sail

Size: 440 x 280mm (17¼ x 11¼in)

This is a painting of the same scene as the step-by-step demonstration on pages 28–34, again at low water but at a different time of day, with the light source much higher in the sky. It was not a particularly bright day, but there was sufficient light to create a moody atmosphere with a rich colour scheme.

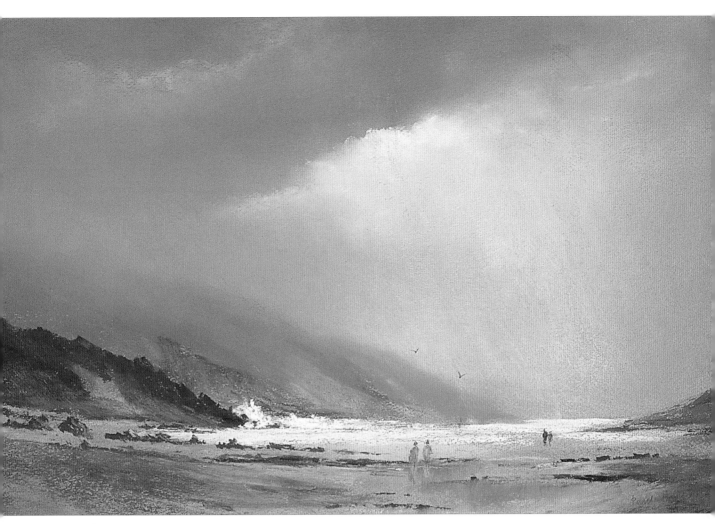

Ominous Sky!
Size: 475 x 360mm (18¼ x 14¼in)

I painted this version of the estuary on a rather cold misty day with low clouds rolling across the cliff tops. The soft atmosphere creates a certain mystery. The drama of the scene is emphasised by a low horizon and a wider than usual seascape format.

Townscape

This final step-by-step demonstration is a townscape. This is a scene in a city that has an abundance of good subjects for the artist.

This particular view caught my eye because of the wonderful range of colours produced by the warm glow from the evening sky. The light source, out of the picture at the left-hand side, created a pattern of light and dark between the buildings. The shadows on the pavement and road were rather intense, but the colour scheme of the whole scene had a balanced tonal value.

The perspective of the buildings, simple boxes that get smaller and narrower as they get further away, had its own appeal, and this was emphasised by the colours which became cooler and weaker as they receded into the distance.

You will need

Soft pastels:
 white
 warm-blue (very pale, pale and medium)
 warm-grey (very pale, pale and medium)
 raw sienna (dark)
 orange (medium and dark)
 yellow ochre (pale and medium)
 cool-yellow (very pale and pale)
 black-brown (dark)
 red-brown (medium and dark)
 crimson (very pale)
 violet (pale, medium and very dark)
Pastel pencil: white
Charcoal pencil

Pencil sketch used as the reference for this demonstration

1. Use a charcoal pencil to draw the basic outlines.

38

2. Cover the sky area with a medley of colours –
pale and medium warm-blue, medium and dark
orange, dark raw sienna, medium yellow ochre and
pale cool-yellow – making the left-hand side of sky
lighter than the right.

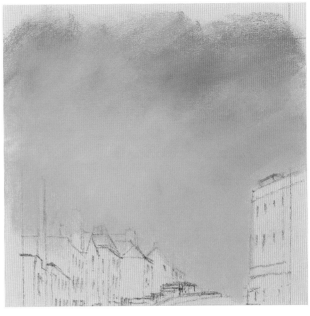

3. Blend the colours together.

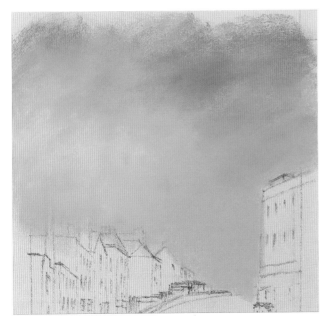

4. Use white to lighten the left-hand side, then
gently rub this into the background colours.

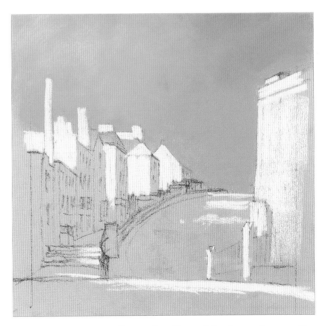

5. Using a very pale cool-yellow, block in the sunlit
sides of the buildings and sunlit areas in the road.

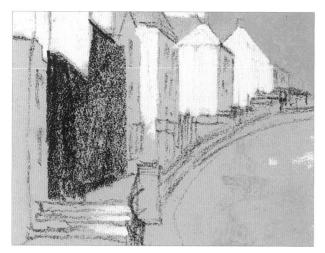

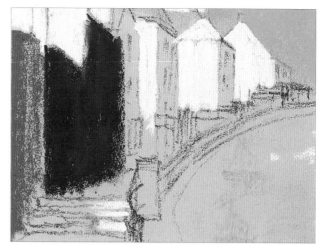

6. Use a dark black-brown to block in the shadowed side of the brick buildings.

7. Overlay the black-brown with a dark warm-blue, then finger blend the colours together. Block in the nearest building with a medium red-brown.

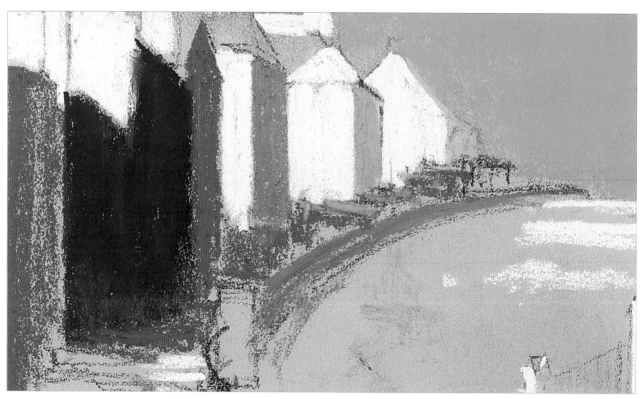

8. Use a pale violet to block the shadowed wall of the building with the gable end and the shadowed areas on the gardens. Block in the other buildings up the hill with medium, pale and very pale warm-greys. Overlay the wall of the first and last of these grey buildings with medium and very pale warm-blues respectively. Use the medium warm-grey to roughly block in the curving wall, then add marks to suggest stepped areas on the pavement.

40

9. Scribble a very pale crimson over the chimneys to create texture. Block in the roofs with dark red-brown, a medium warm-grey and a very dark violet.

10. Define the shadowed sides of the chimney with touches of pale violet, then use a white pastel pencil to soften the marks and define the shapes.

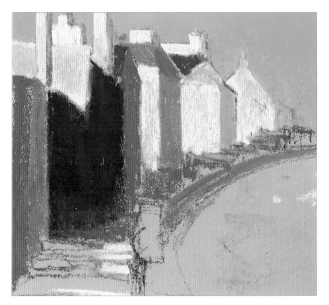

11. Overlay the front wall of nearest building with medium warm grey. Knock back the brightness of the sunlit walls with a pale yellow ochre.

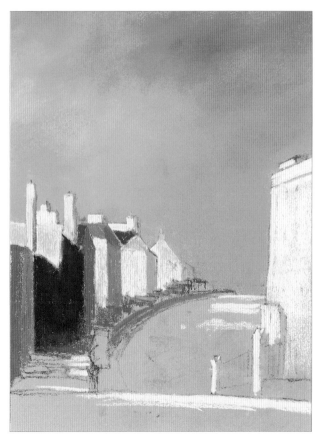

Having stood back to look at the painting at the end of step 11, I decided that the left-hand chimney was too tall. I made it shorter by overpainting it with the sky colours.

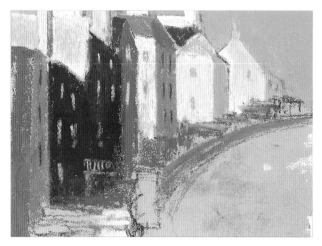 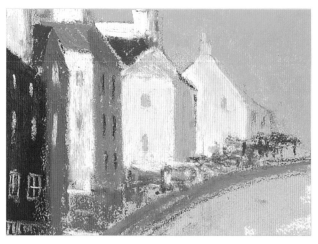

12. Using the tips of white and very pale warm-blue pastels, make small marks to indicate the windows on the darker buildings. Use the charcoal pencil and the medium warm-grey pastel for those on the paler buildings. Make the marks narrower and smaller as buildings recede into the distance.

13. Use the very pale cool-yellow to add highlights to stepped areas on the pavement, and touches of the medium red-brown to denote some of the brick walls in the small front gardens.

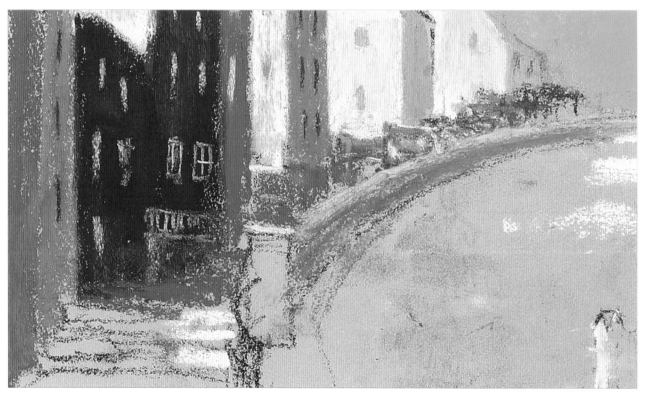

14. Establish the pavement in front of the gardens with a pale warm-grey, then add bright accents of yellow and orange to denote flowers in the sunlit parts of the gardens.

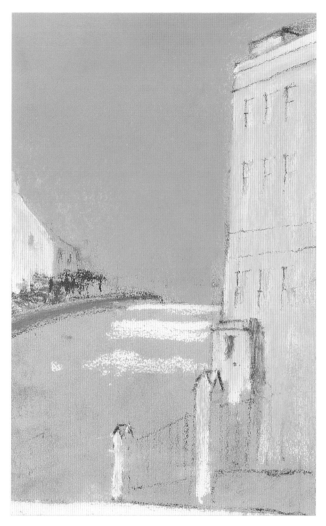

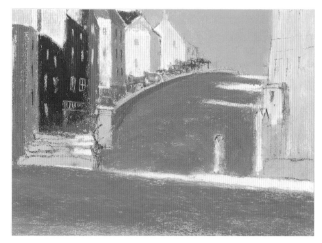

16. Use a medium warm-grey to block in the surfaces of the road in the foreground and up the hill, then overlay these areas with a pale violet. Overlay the curving wall with a medium violet.

15. Use the pale yellow ochre to knock back the sunlit walls on the right-hand building. Use the very pale warm-blue and the pale warm-grey to indicate the windows, then re-establish the shapes with the charcoal pencil.

17. Develop the steps with medium warm-grey and medium violet. Block in the pillar in front of the curved wall with dark black-brown.

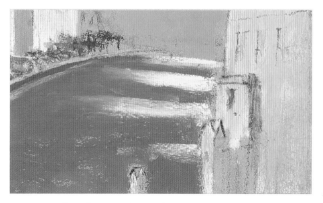

18. Overlay the patches of sunlight on the hill with pale cool-yellow.

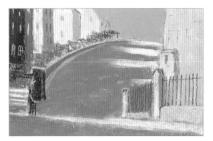

19. Re-establish the wall in front of the right-hand building, then use a charcoal pencil to define the railings. Add the indication of railings by the left-hand steps.

20. Use a charcoal pencil to add fine detail: the two lamp posts; the railings along the pavement; and the deep shadows under the eaves and round windows of the left-hand buildings.

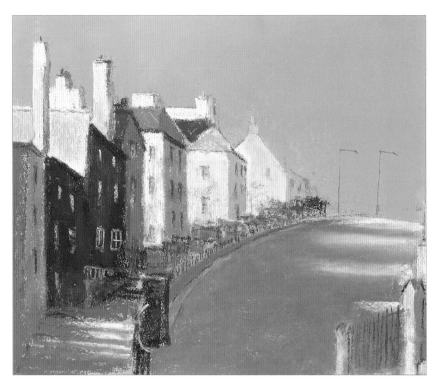

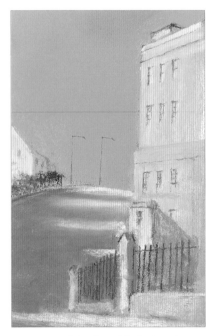

Having stook back and looked at the composition at the end of step 20, I was not happy with the shape of the right-hand building. I reworked it to create a tiered structure, added a cast shadow to the right of the entrance, then reinstated the railings.

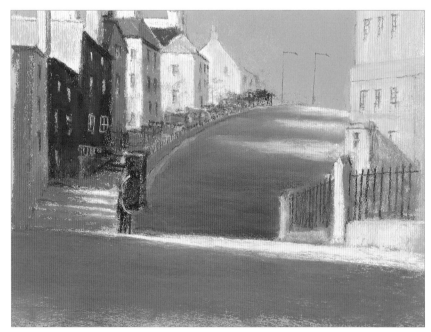

21. Intensify the area of sunlight on the foreground stretch of road with a very pale cool-yellow. Use a dark warm-grey to intensify the shadowed area at the bottom of the hill, reducing the strength as you work up the hill. Use the same colour to increase the depth of shadow at the left-hand side of the foreground.

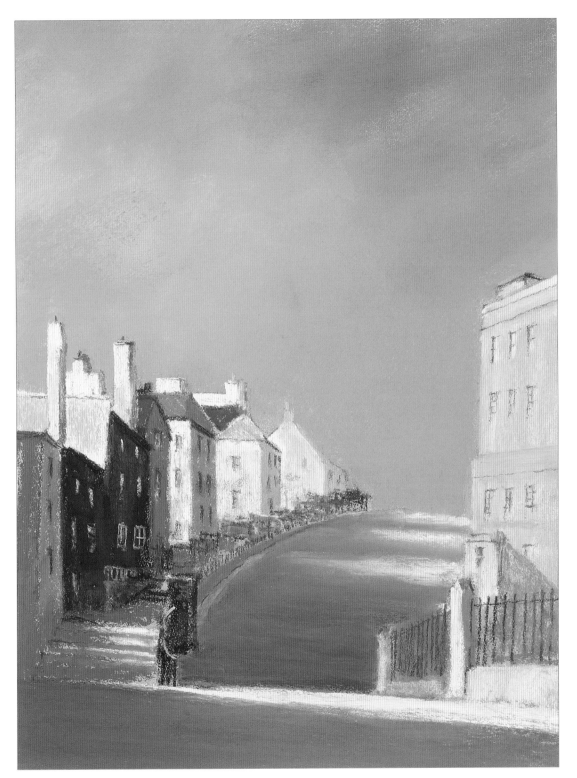

The finished painting
Size: 240 x 320mm (19½ x 12½in)

Having stood back to look at the composition after step 21, I decided that the distant lamp posts distracted the eye, so I removed them by overlaying some more yellow and blending this into the sky.

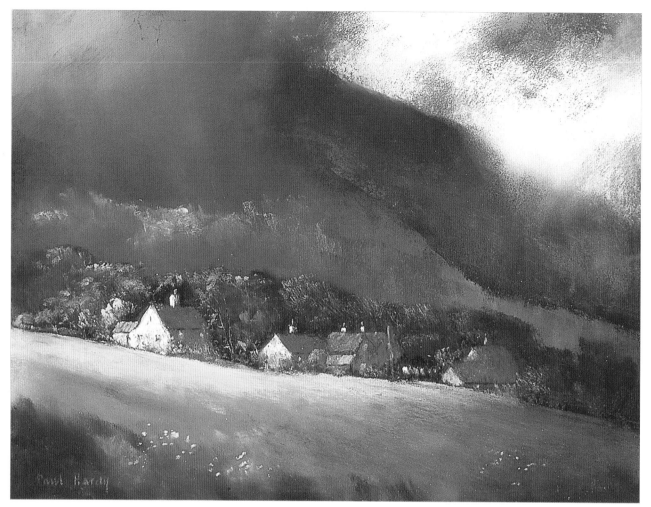

Welsh Valley

Size: 300 x 220mm (11¾ x 8¾in)

When I first saw these buildings, nestling in the folds of the Welsh mountains, the light was such that they were hardly visible against the dark background tones. Suddenly, the evening sun broke through the storm clouds and lit up the foreground with rich warm colours – raw sienna, burnt sienna and yellow ochre. The reflected light, bouncing off the west-facing walls of the buildings, gives added depth to the composition.

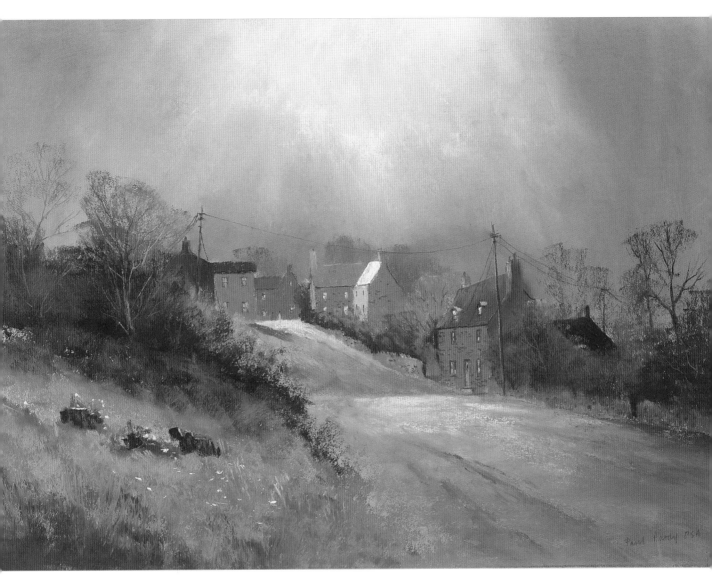

Going Home

Size: 550 x 390mm (21½ x 15¼in)

This is another composition that would have looked quite drab had it not been for a break in the clouds. The light, although weak, was more than enough to brighten the foreground and highlight the buildings against the misty background. Note how the tonal value of each building varies with its relative position to the light source. The really bright roof of the middle cottage in this composition suggests recent rain. Telegraph poles are often regarded as distractions, but, here, they provide a link between the two sides of the composition, and help the eye move around the painting.

Index

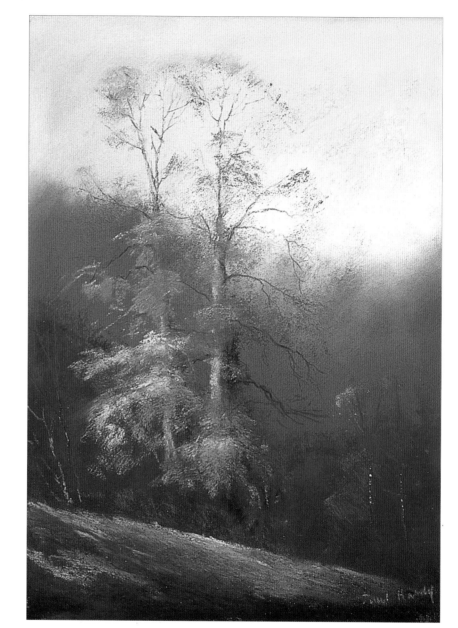

Trees in Autumn
Size: 220 x 305mm (8¾ x 12in)

It was late autumn when I painted these trees. Most of the upper foliage had been blown away by recent strong winds. However, there were still sufficient leaves lower down the trunk to catch the available light and create some interesting patches of colour set against the dark background.